I LEFT A NOTE

— PORK

LADIES AND GENTLEMEN — WE IMPLORE YOU — DO NOT GO INSIDE. IF YOU DO, NOTHING GOOD WILL COME OF IT. LADIES AND GENTLEMEN — PLEASE KEEP WALKING BY. DO NOT LET YOUR MORBID, CRAVED CURIOSITY LEAD YOU DOWN THIS PATH...WE FORBID IT. CROSS THE STREET, AVERT YOUR EYES, PULL YOUR COATS TIGHTLY AROUND YOU AND WALK AWAY. LADIES AND GENTLEMEN — DO NOT LOOK BACK, KEEP ON MOVING, DON'T STOP... NO. RETURN TO YOUR HOMES, LOCK YOUR DOORS, GATHER YOUR FAMILIES AND/OR LOVED ONES. LADIES — REMEMBER LOT'S WIFE AND ERR ON THE SIDE OF CAUTION. MEN AMONG YOU — EXERCISE THE BETTER PART OF VALOR AND LIVE TO FIGHT ANOTHER DAY. DO NOT LET YOUR OVERWHELMING DESIRE, YOUR LUST FOR WONDER ITSELF, COMPEL YOU TO STEP ONE FOOT NEARER. LADIES — YOU ARE THE SENSIBLE ONES, THE CHASTE ONES, THE BLESSED HERD ANIMALS OF HUMANITY. GENTLEMEN—DO NOT CHARGE IN HEADLONG IMMEDIATELY, THIS IS NOT FOR YOU! YOU ARE NO KNIGHTS OF YORE, YOU LOVABLE TEA DRINKING OLE NEUTERS. GO BACK INTO YOUR HOMES WHERE IT IS SAFE, WE BEG OF YOU. LADIES — YOU FAIREST OF GOD'S CREATURES, MOST DOE-EYED AND ALMOND SHAPED OF THE LAND GENDERS, FOR HEAVEN'S SAKE, DO NOT ENTER! LADIES, PLEASE — LET THOSE WITH EARS HEAR — SHUT YOUR BOOKS AND PUT AWAY YOUR MARIJUANA CIGARETTES, YOUR APPETITES CANNOT CONTEND WITH WHAT LIES WITHIN. PRETEND YOU NEVER SAW THIS DREADFUL PLACE. AVERT YOUR VACANT, LISTLESS EYES AND CAST THIS MEMORY INTO THE PIT OF FORGET BEFORE IT CONSUMES YOU, SHUDDERING BREATHLESSLY WITH LUST, HAVING BEEN TRANSFORMED INTO AN UNRECOGNIZABLE FORM... LIKE A BEAVER WITH WINGS. FOR THERE ARE NO TREES IN THE CLOUDS, NO RIVERS IN THE SKY WAITING TO BE DAMNED. PUT DOWN YOUR WINGS AND FORGET ONCE AGAIN. LADIES AND GENTLEMEN — DO NOT READ THE WRITING ON THE WALL.

—SPAM

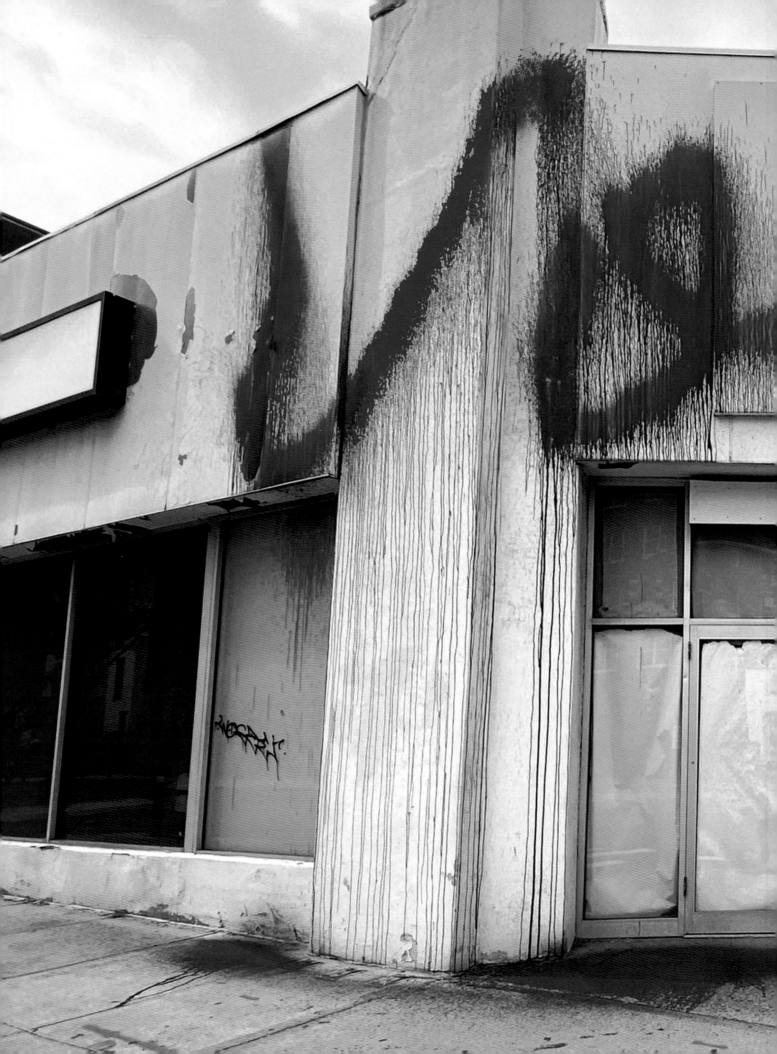

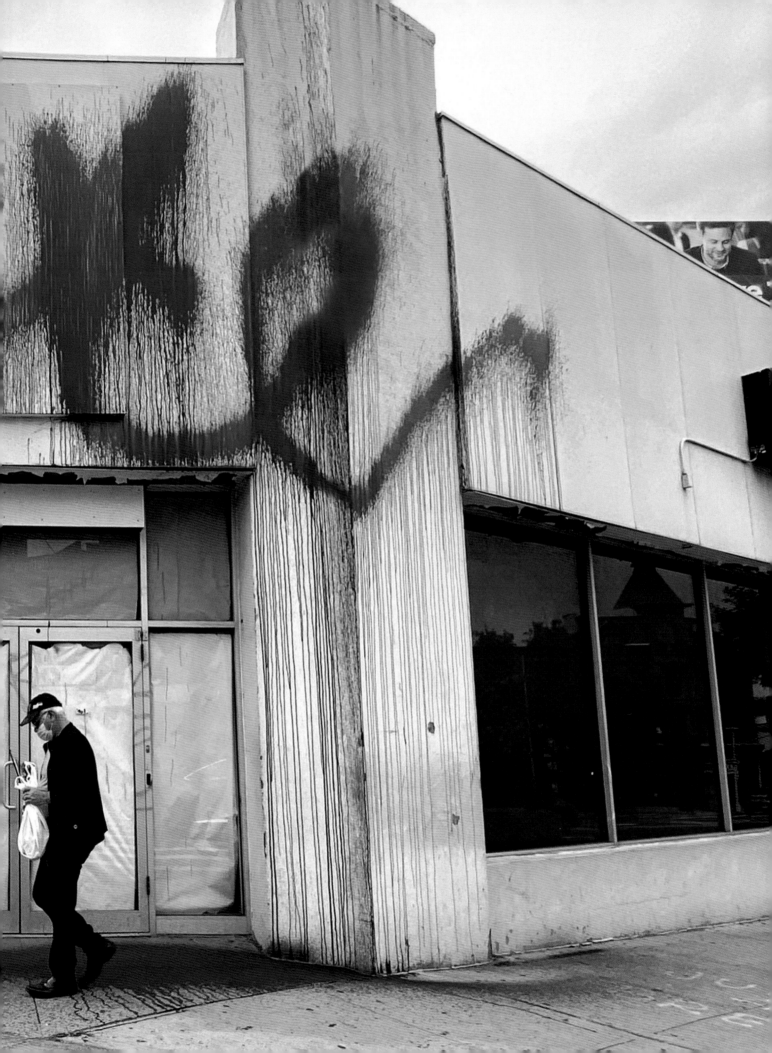

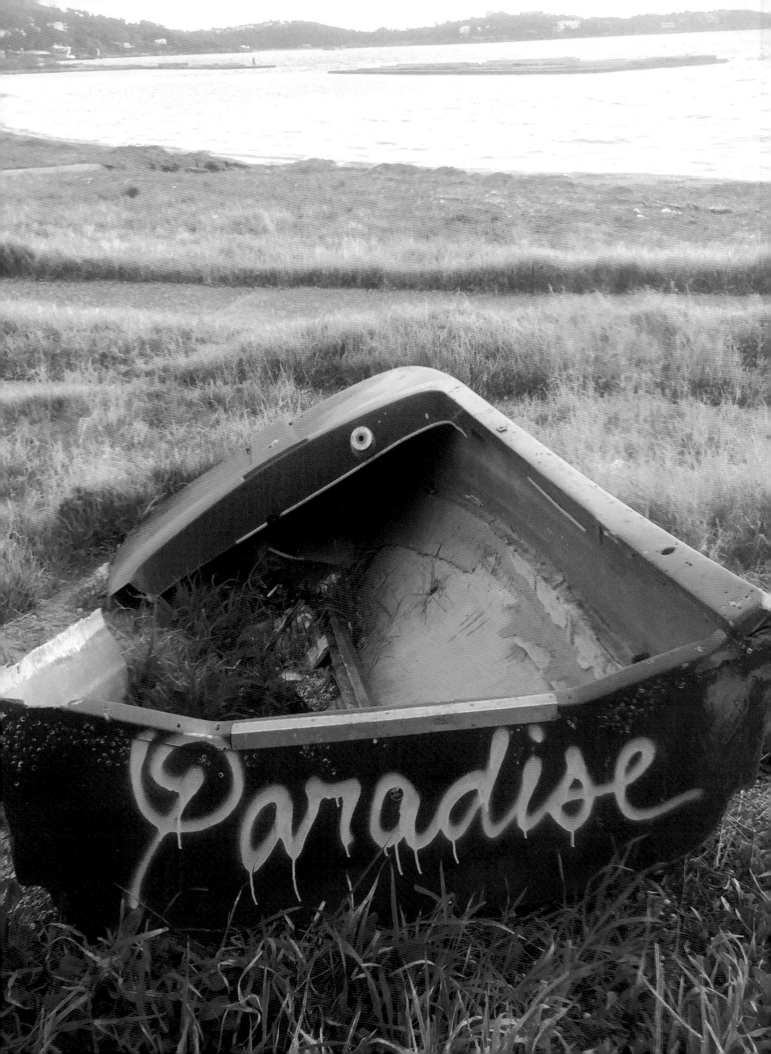

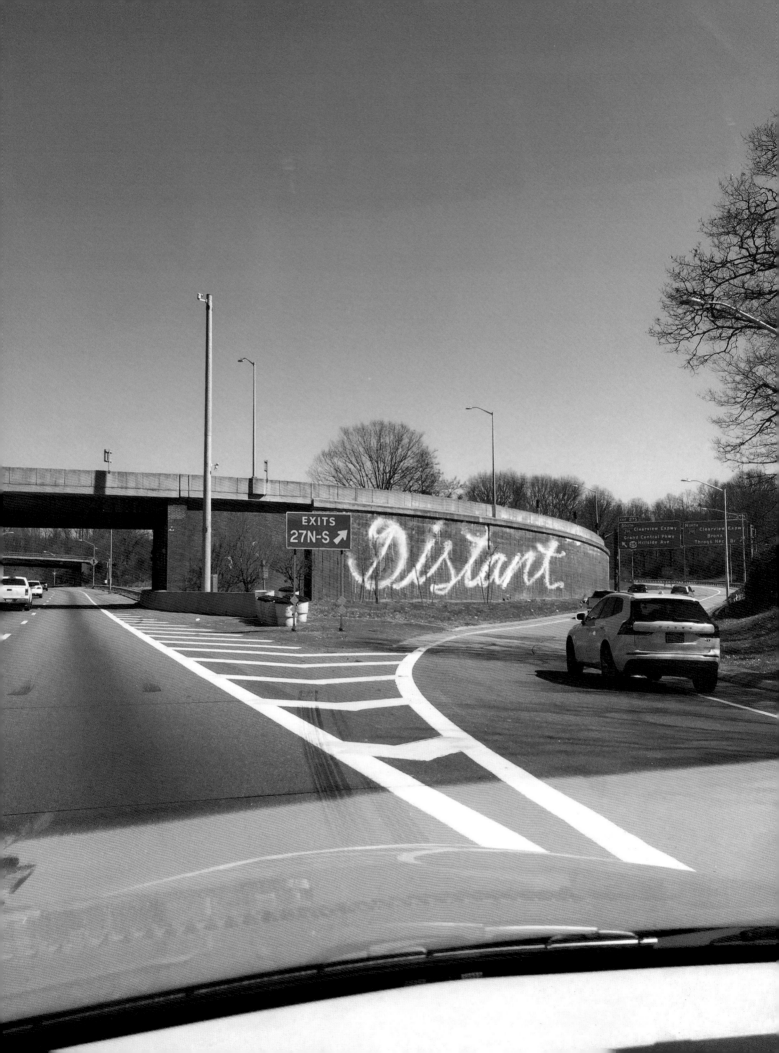

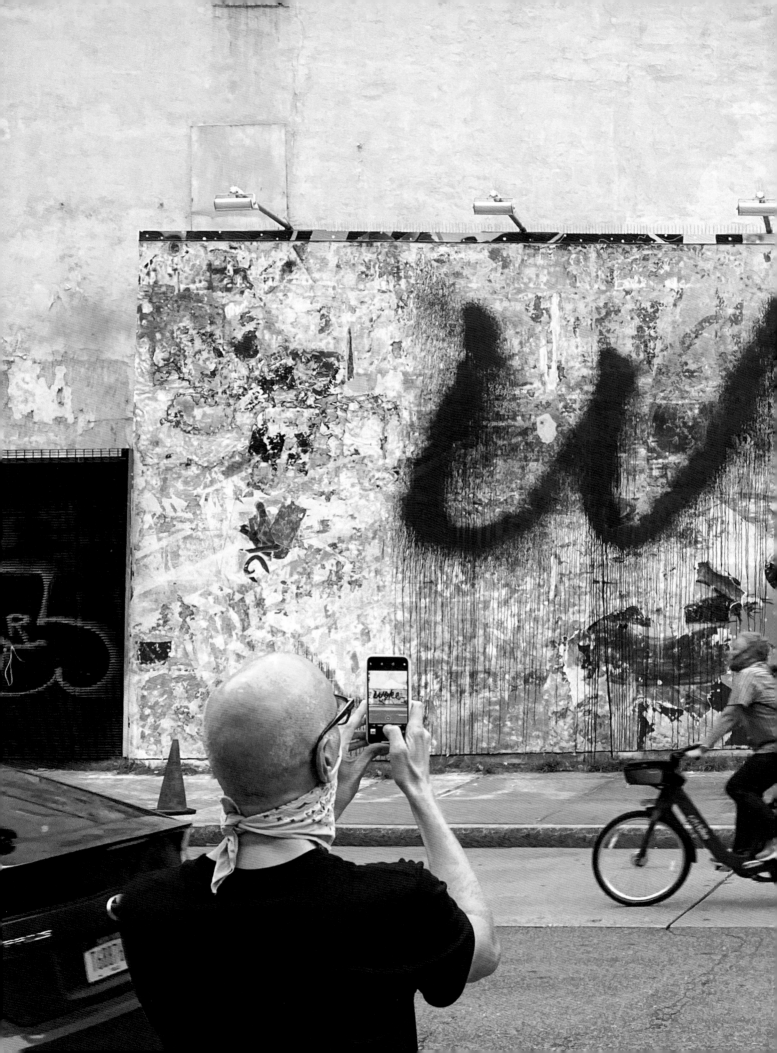

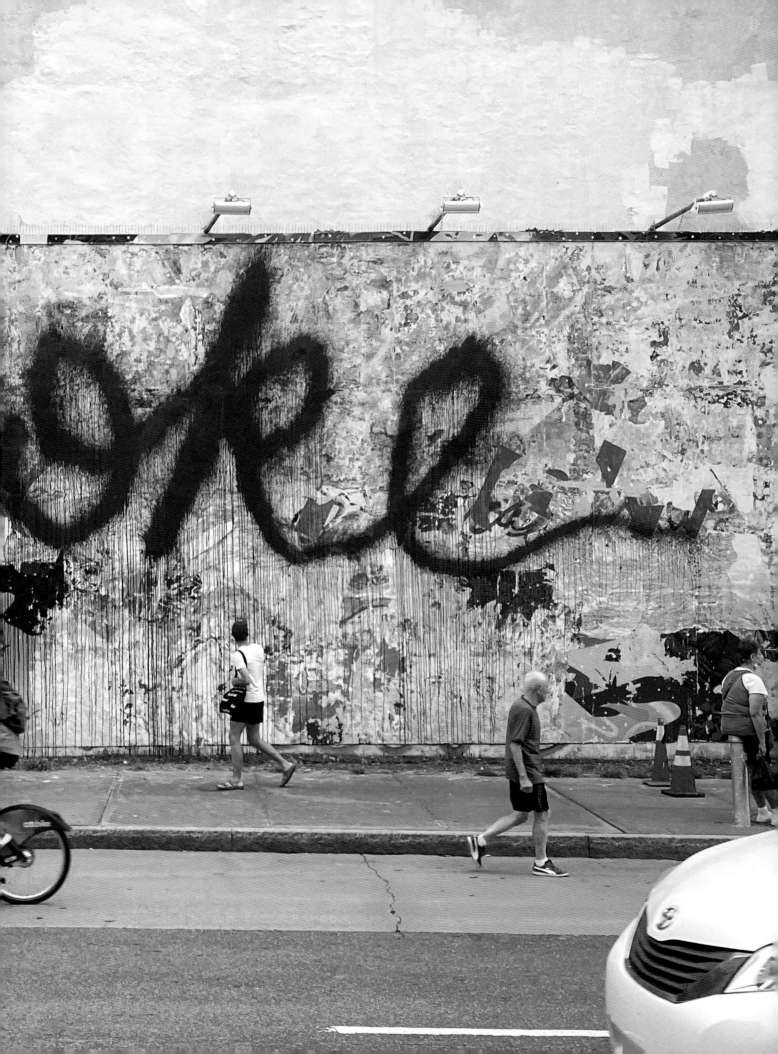

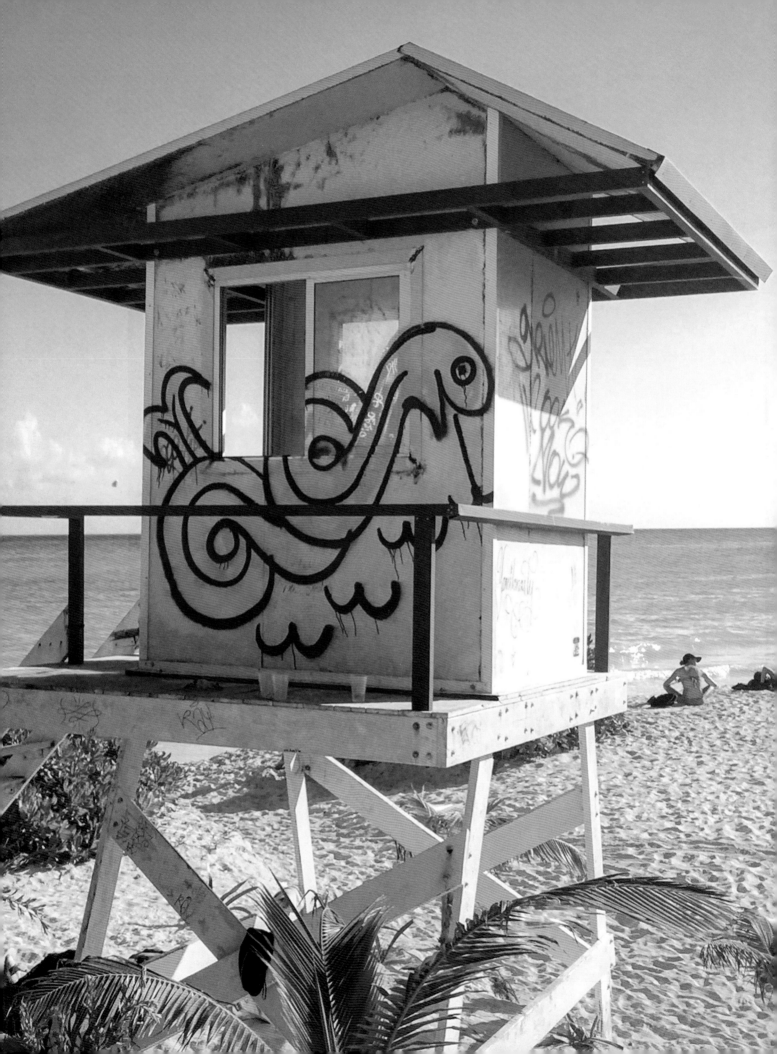

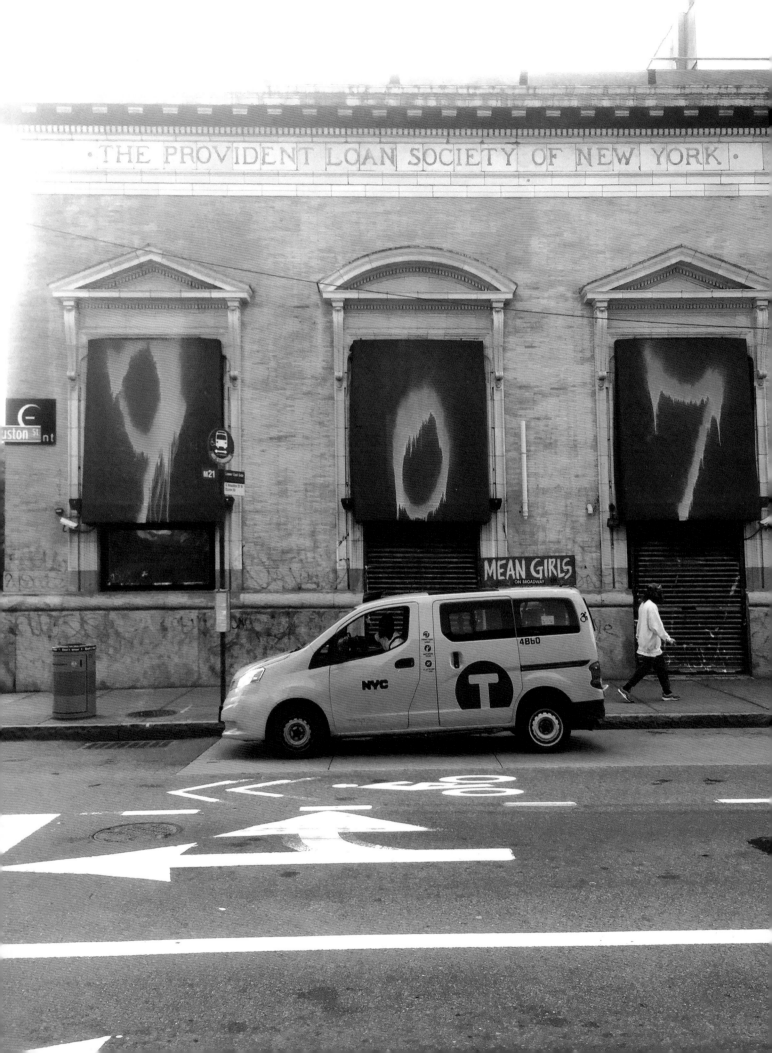

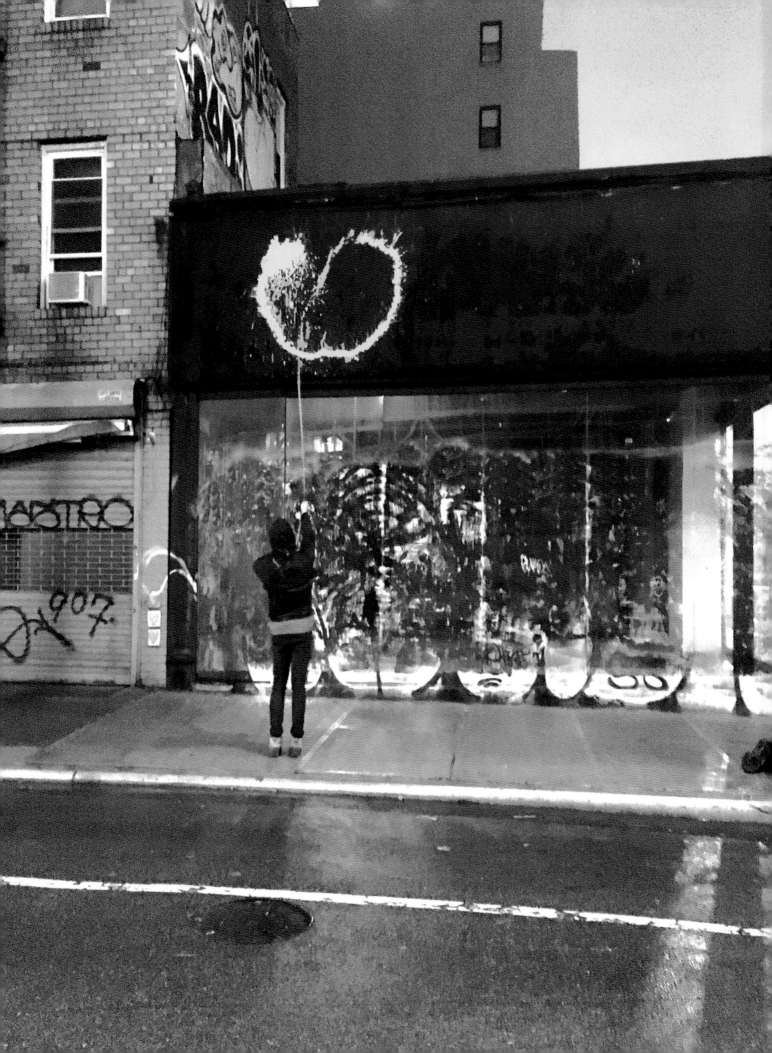

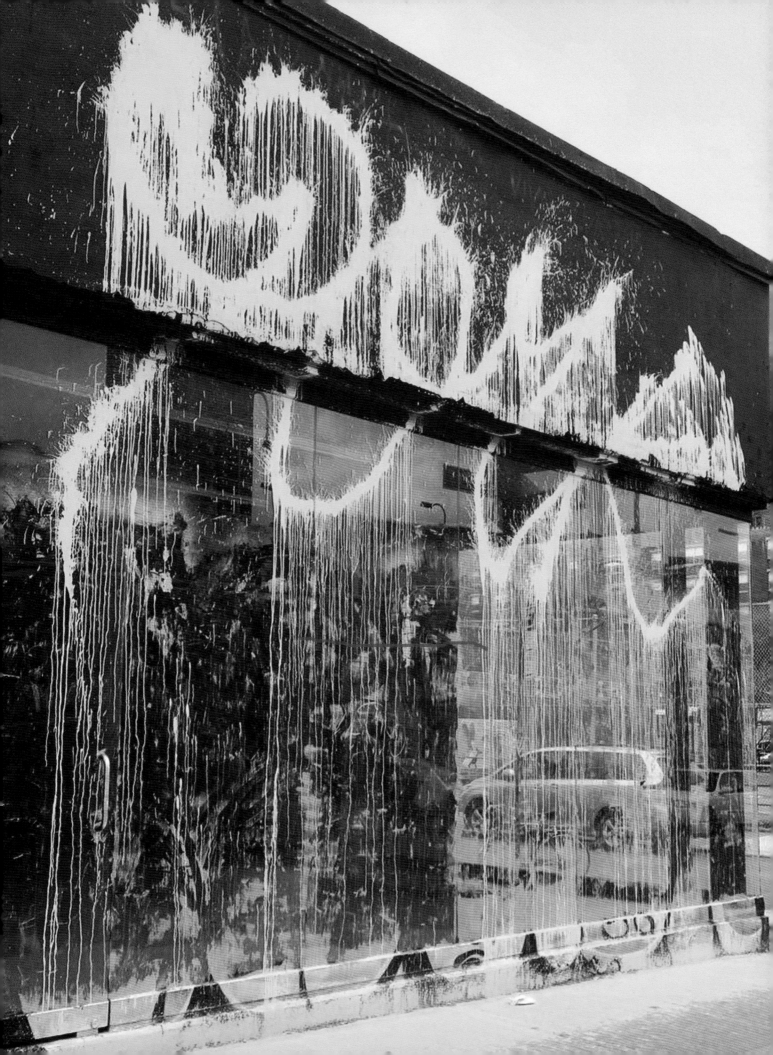

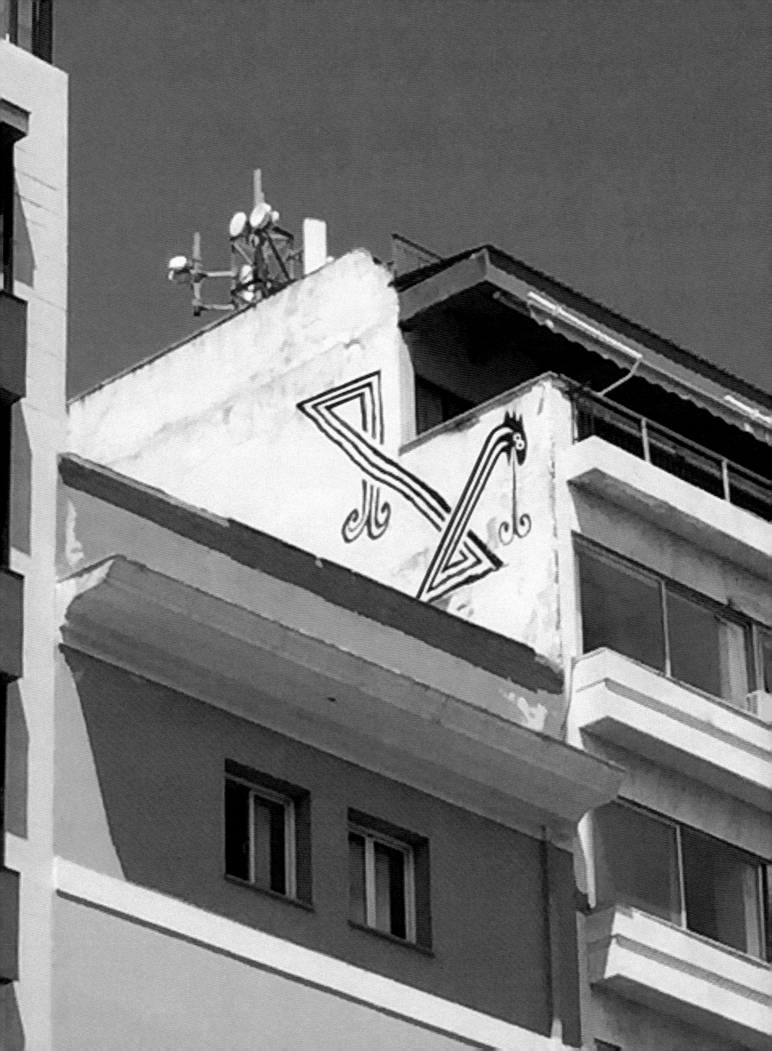

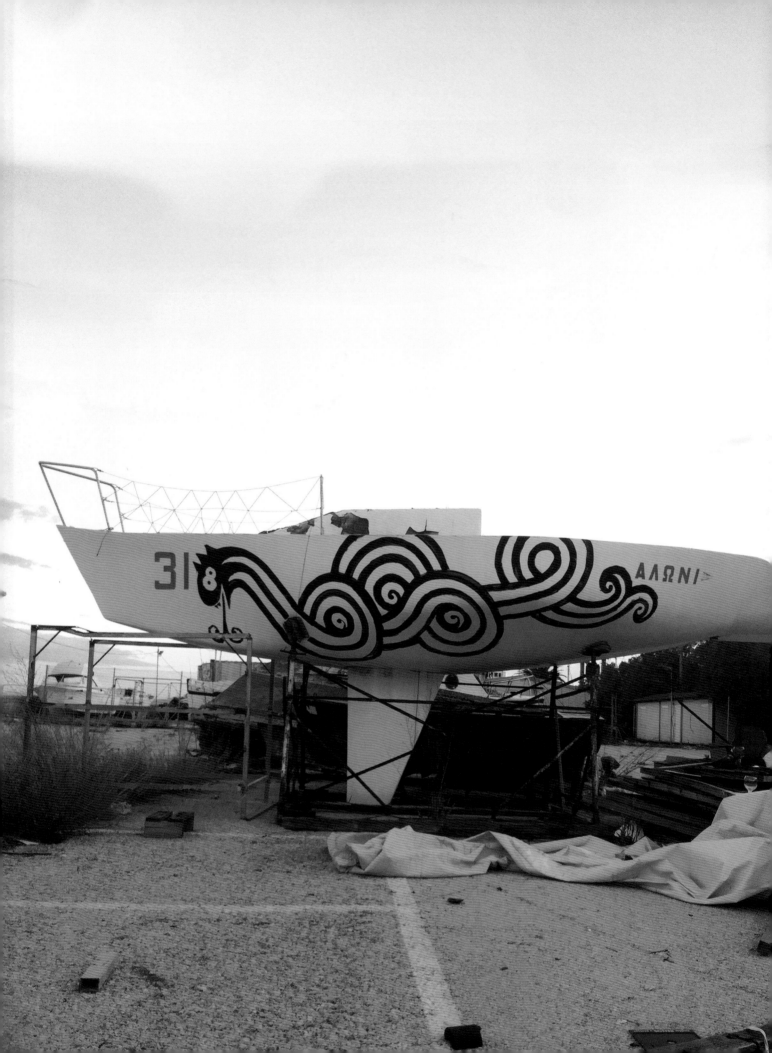

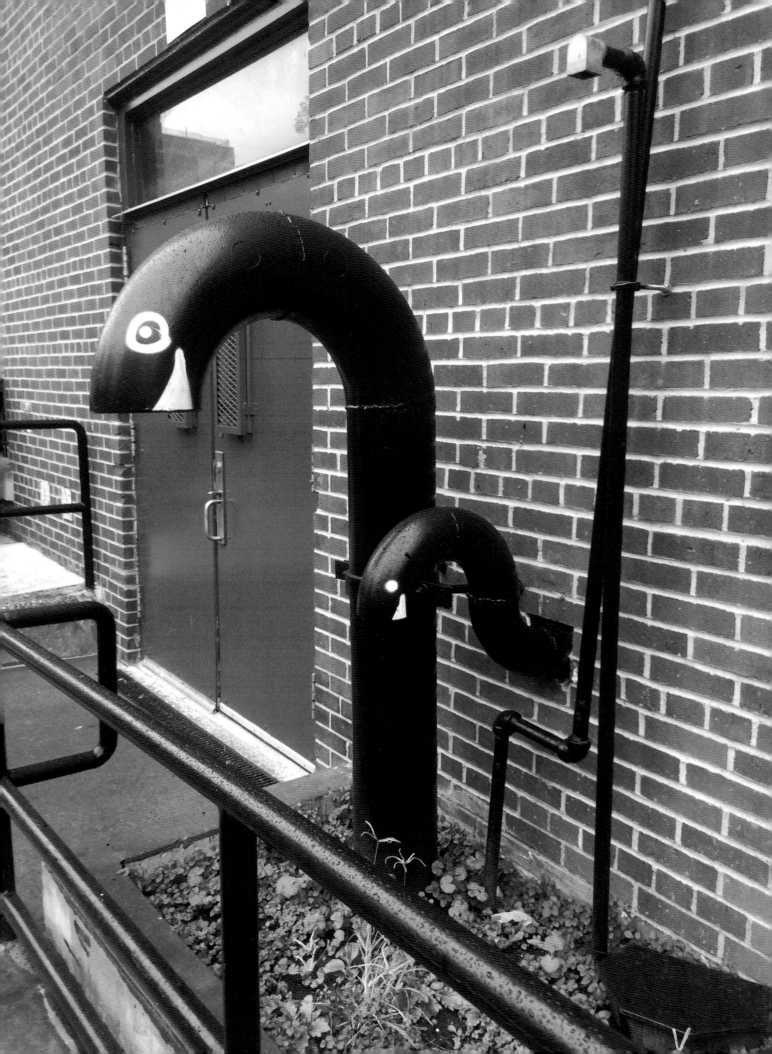

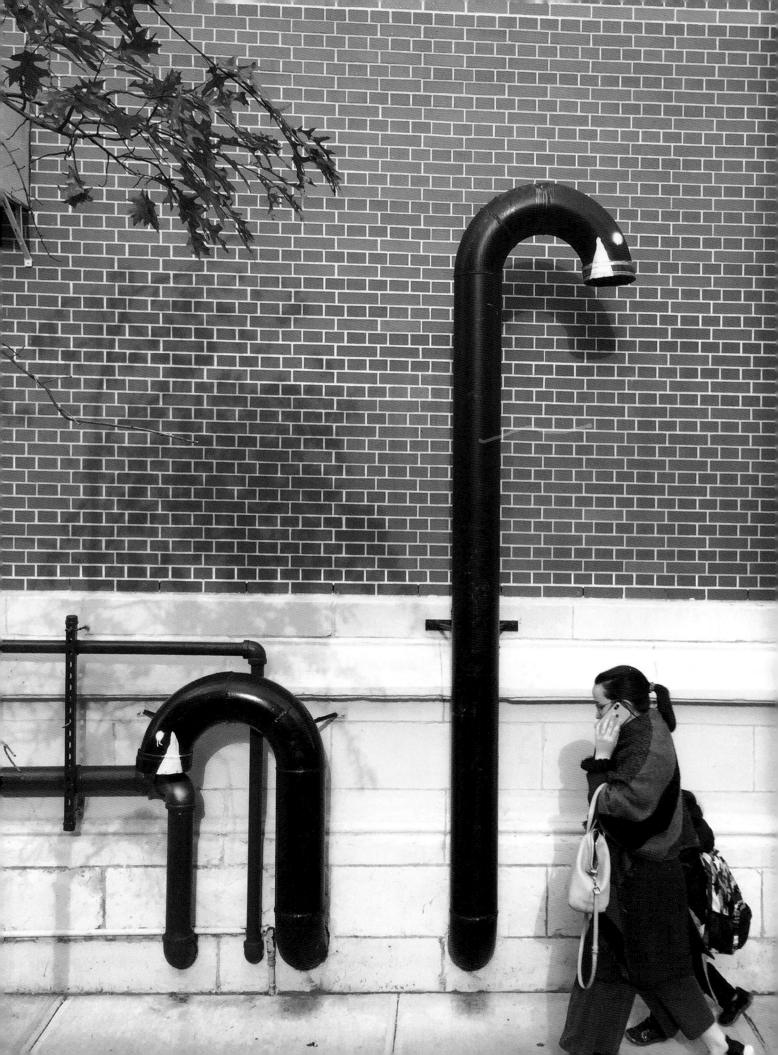

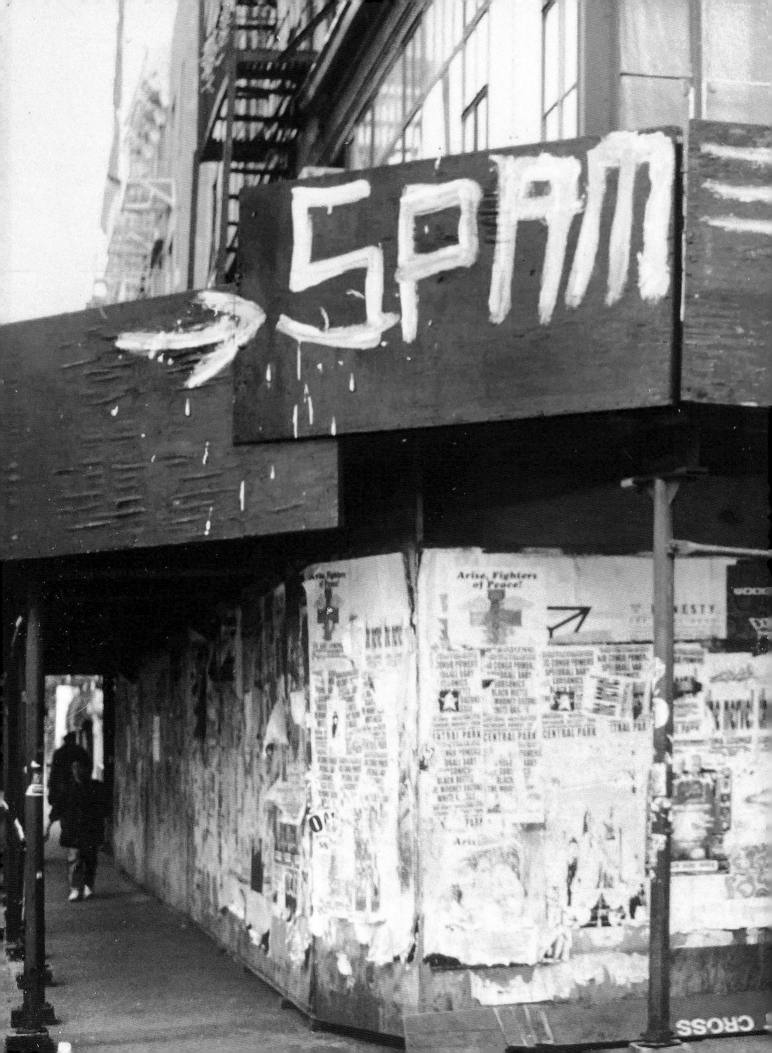

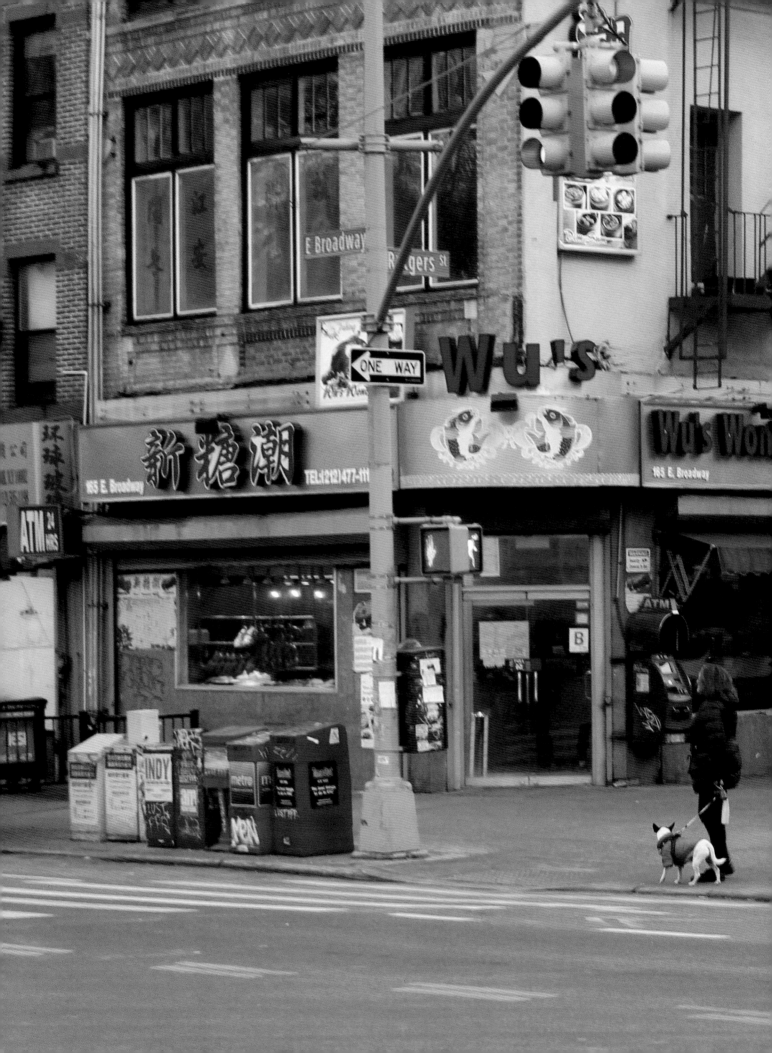

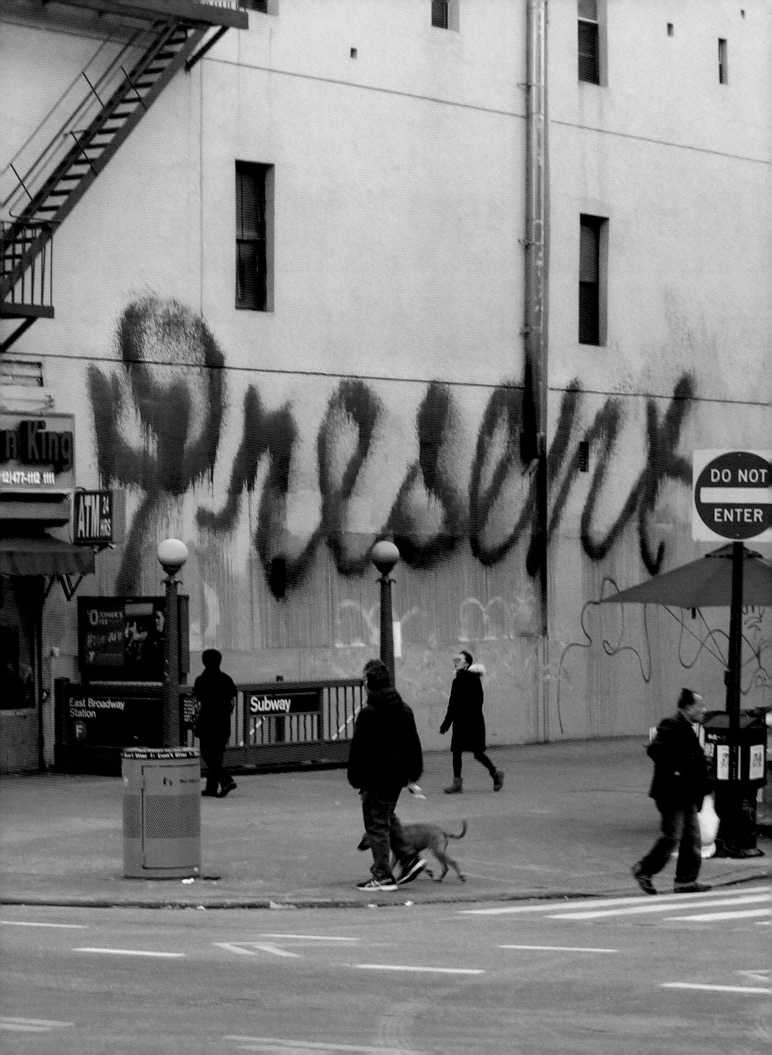

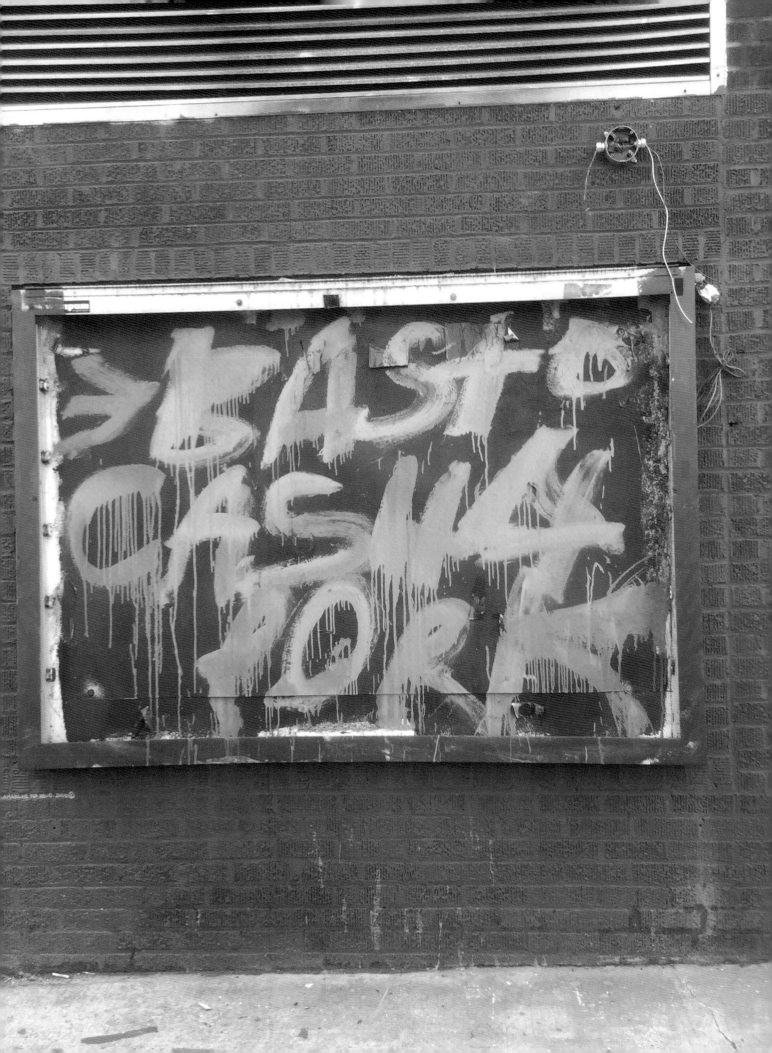

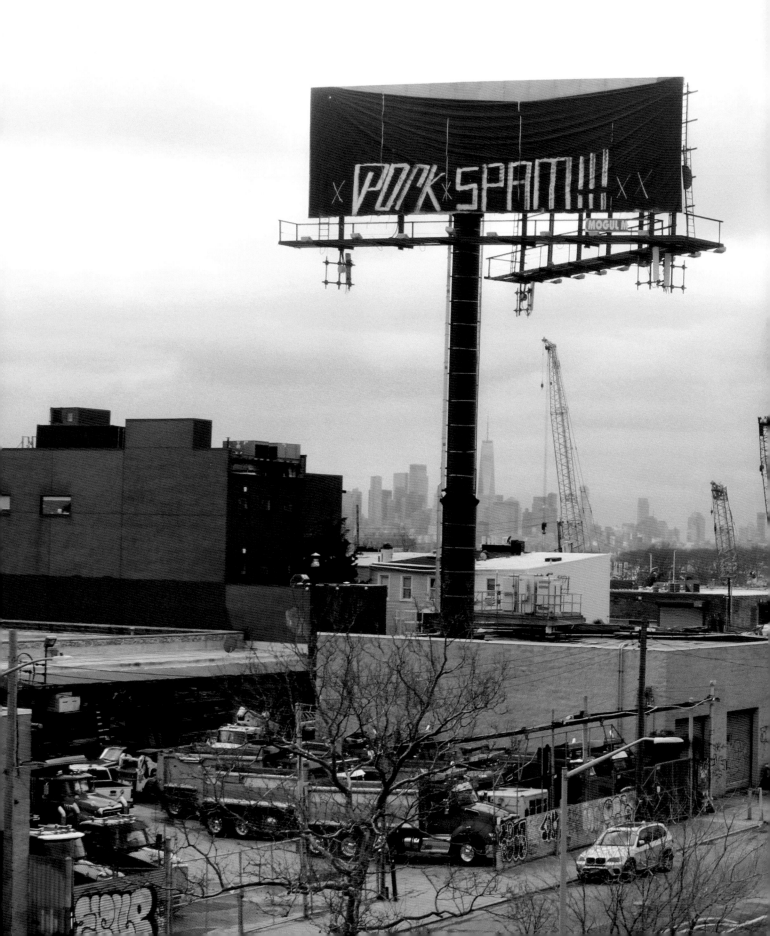

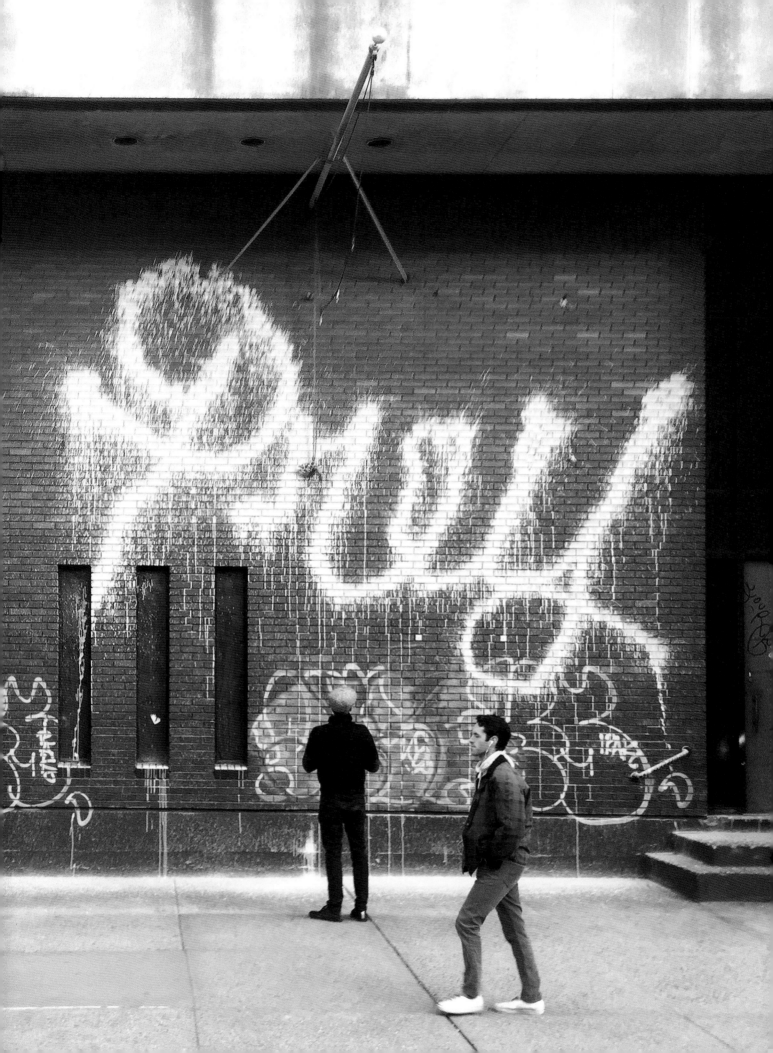

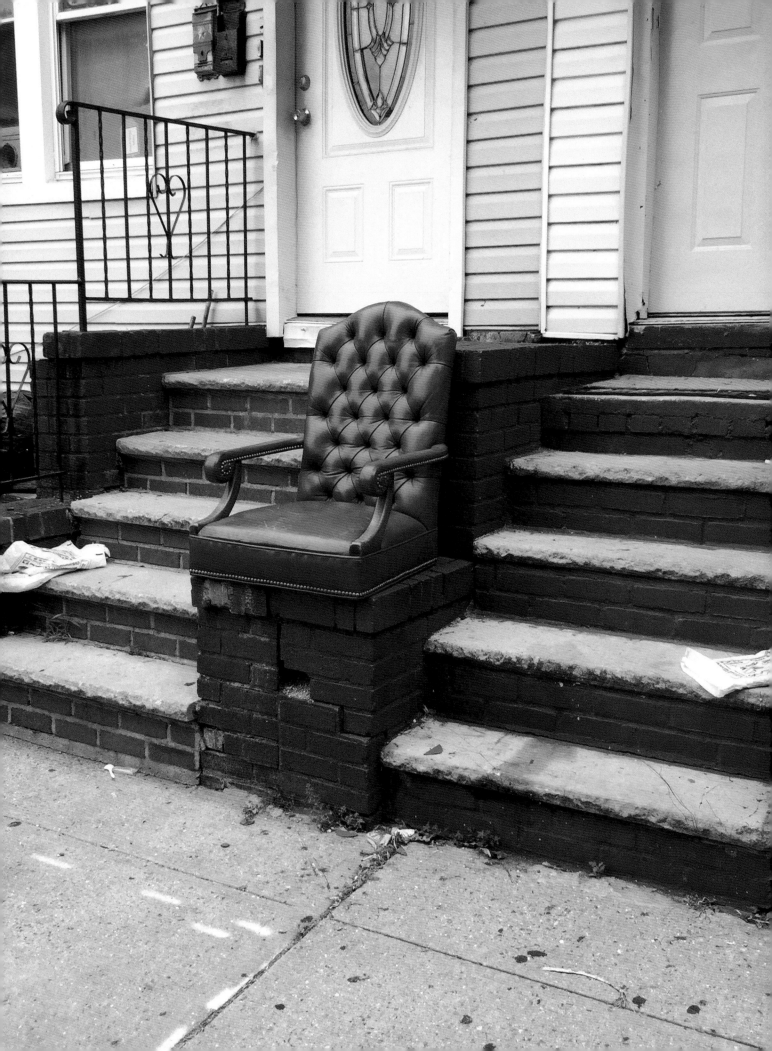

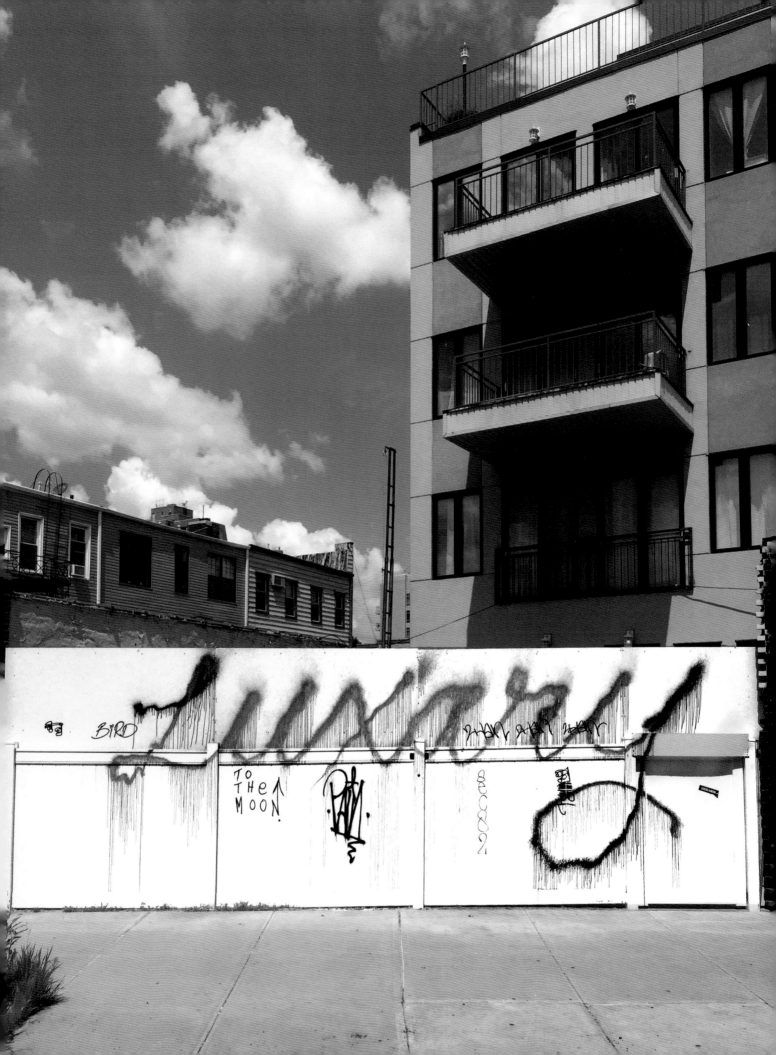

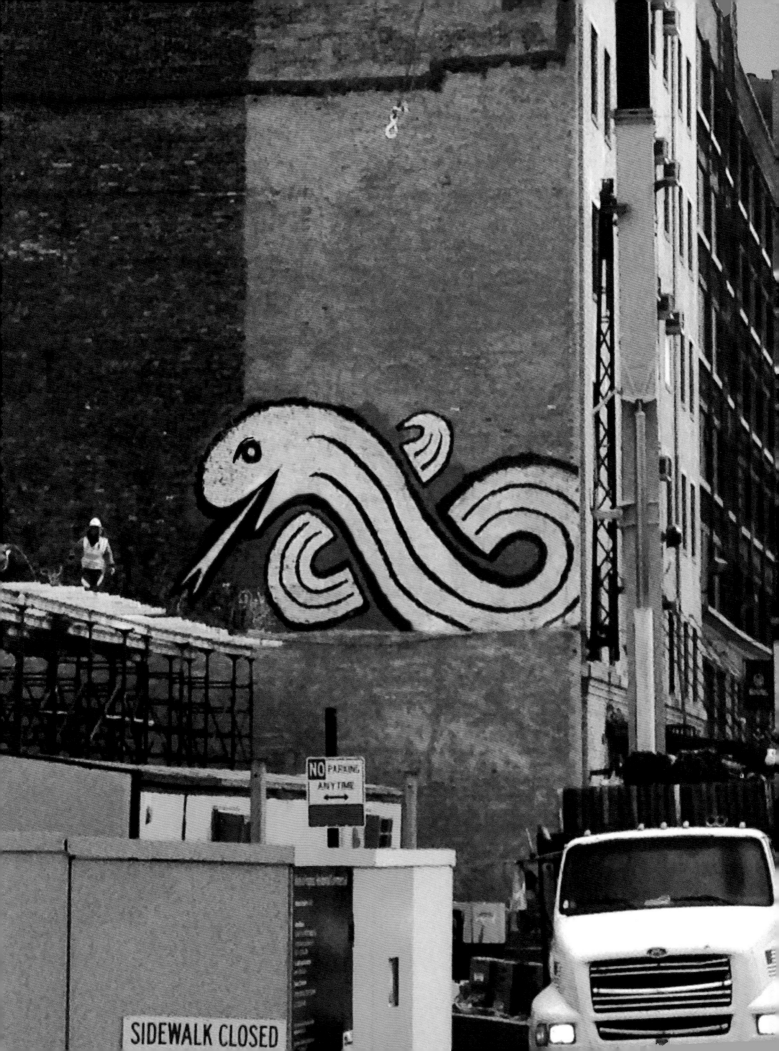

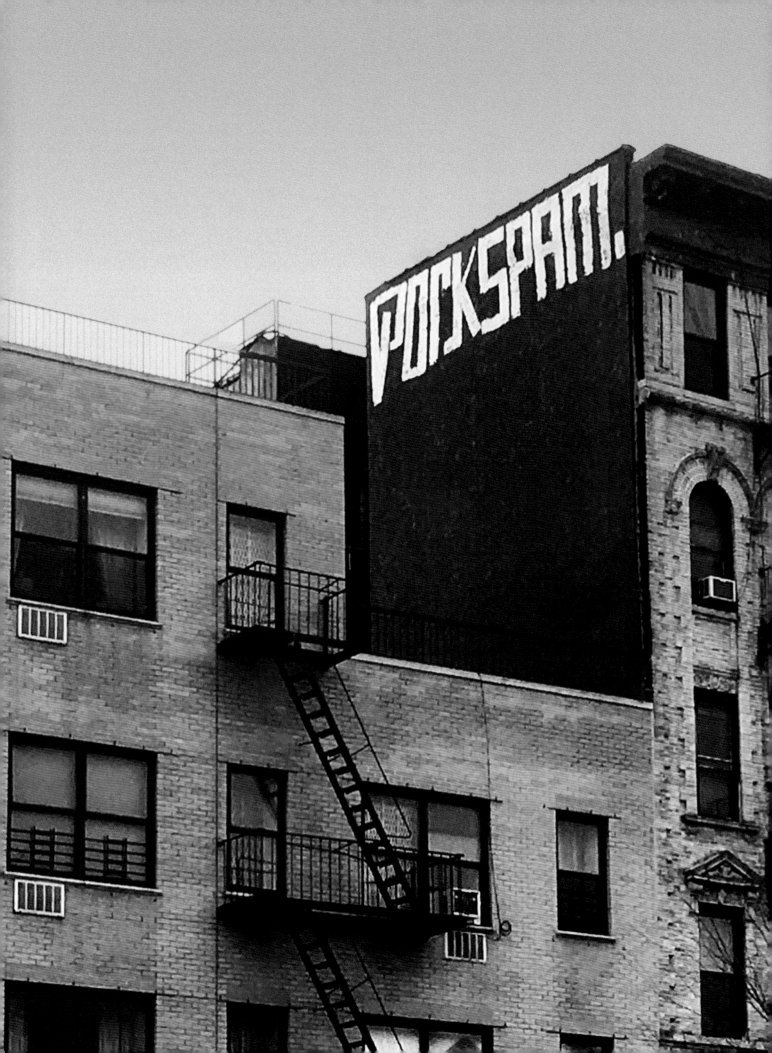

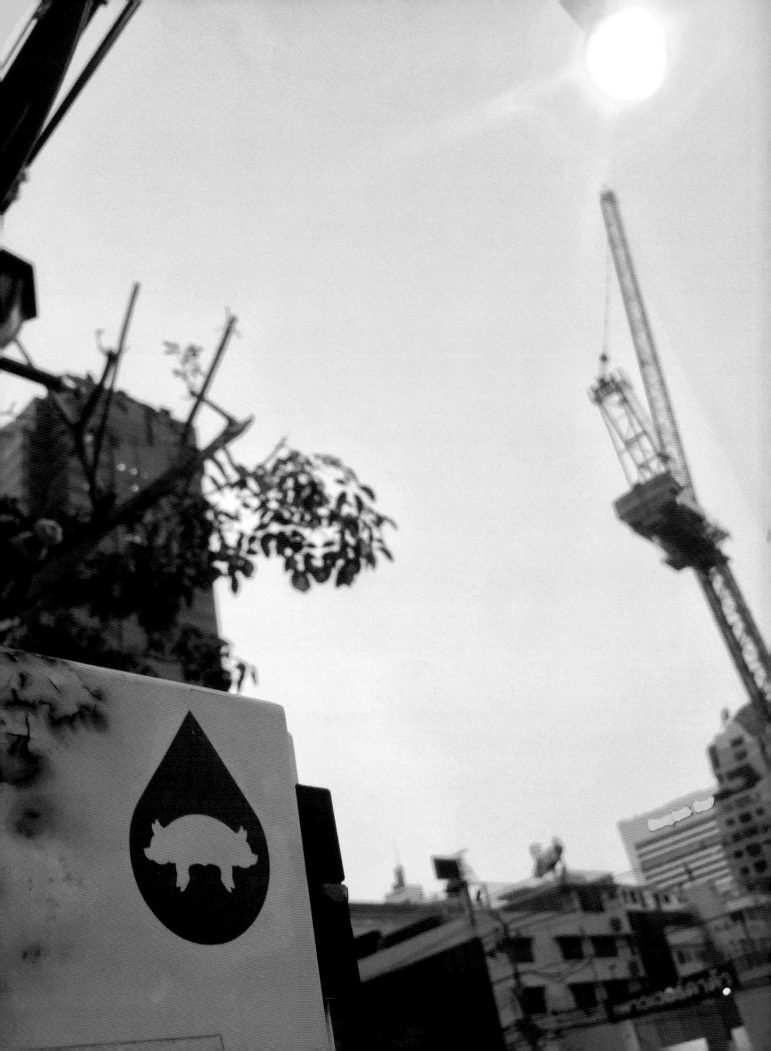

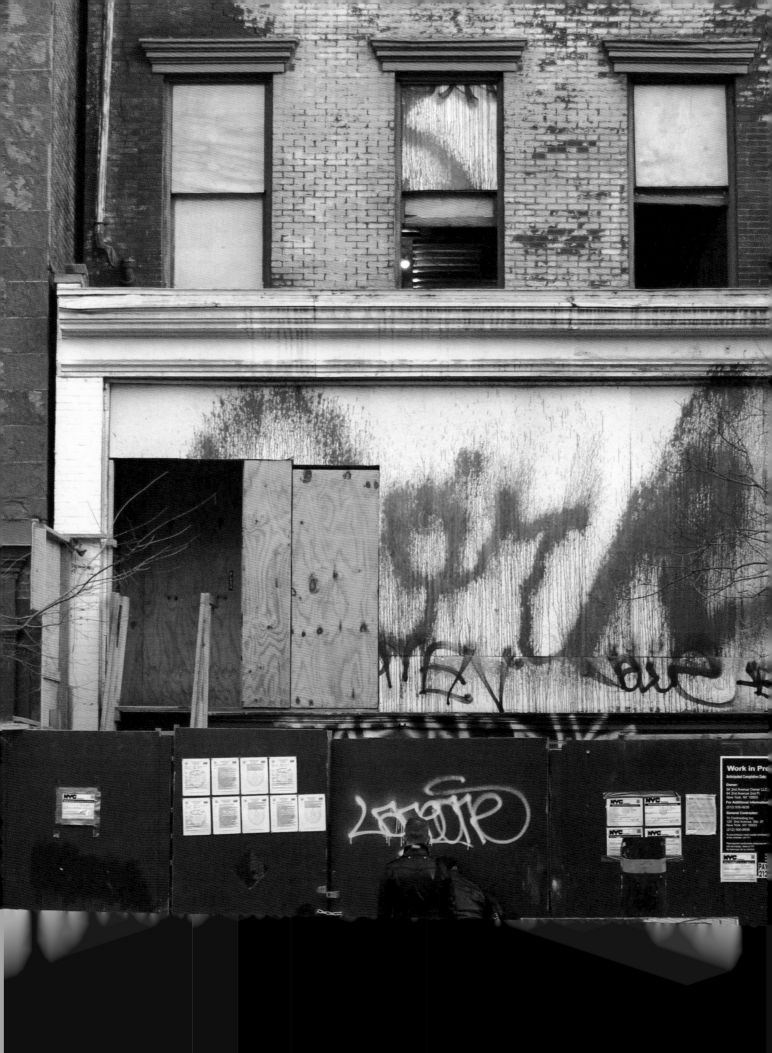

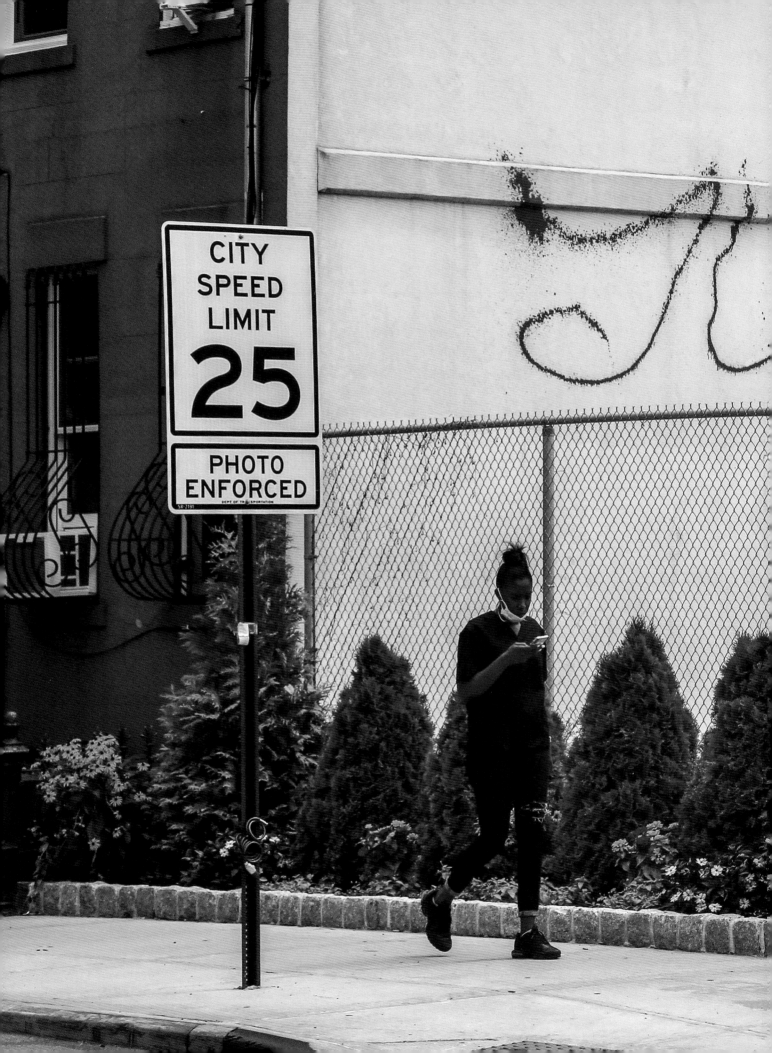

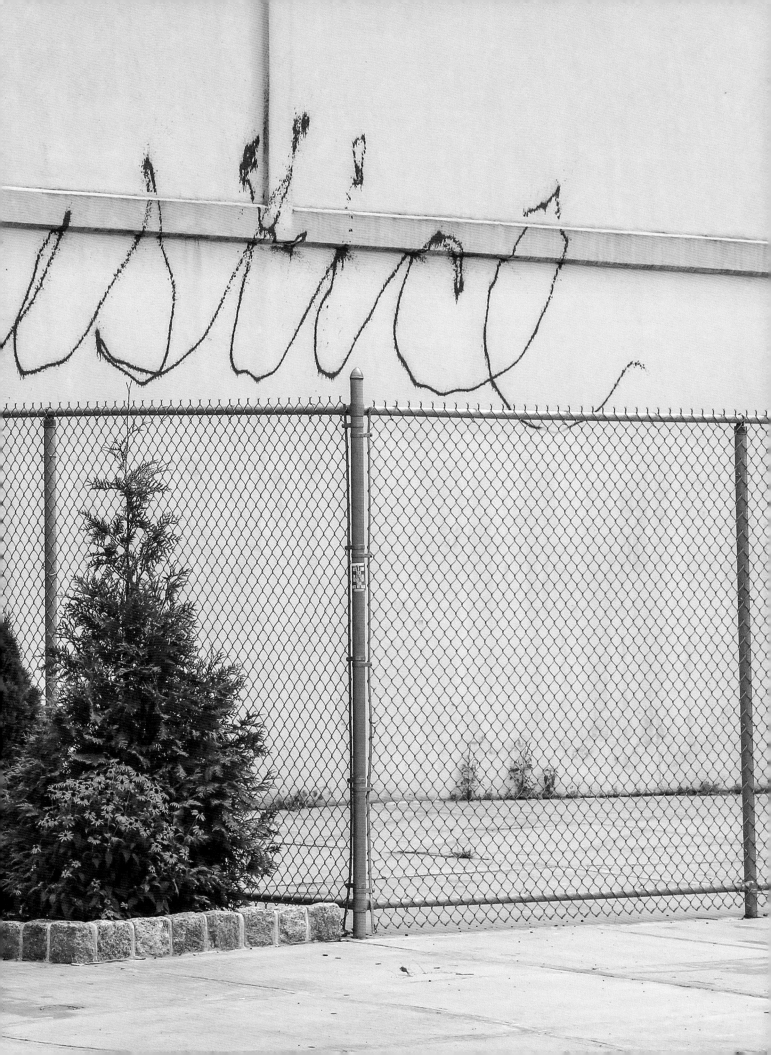

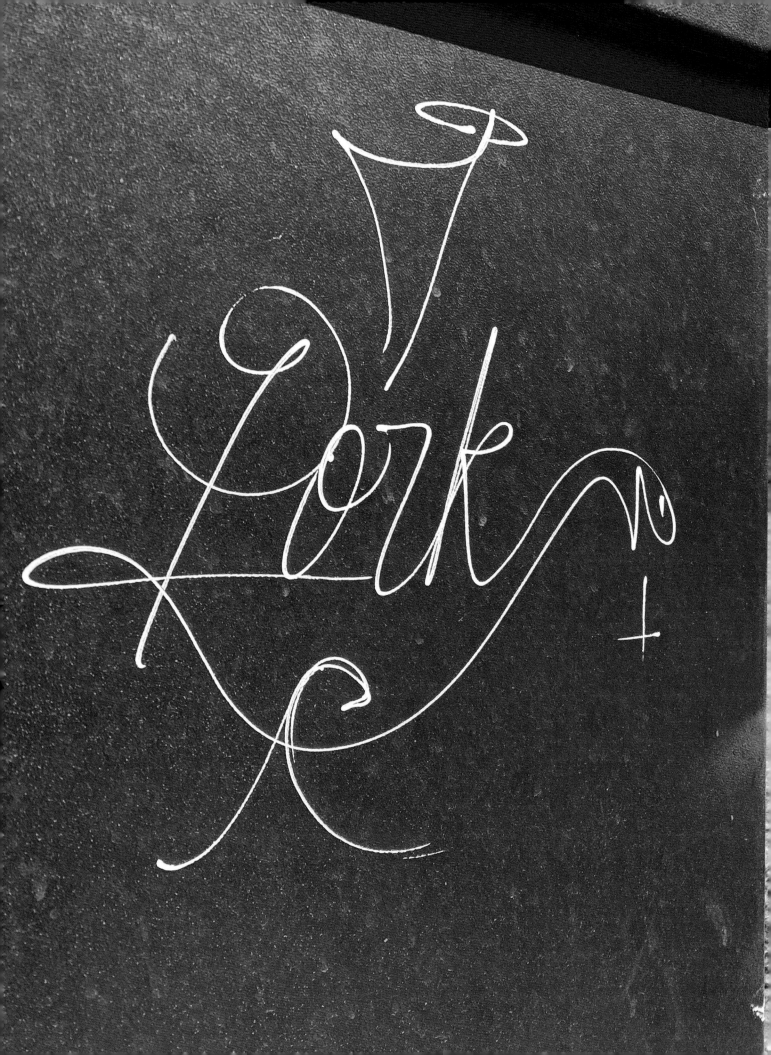

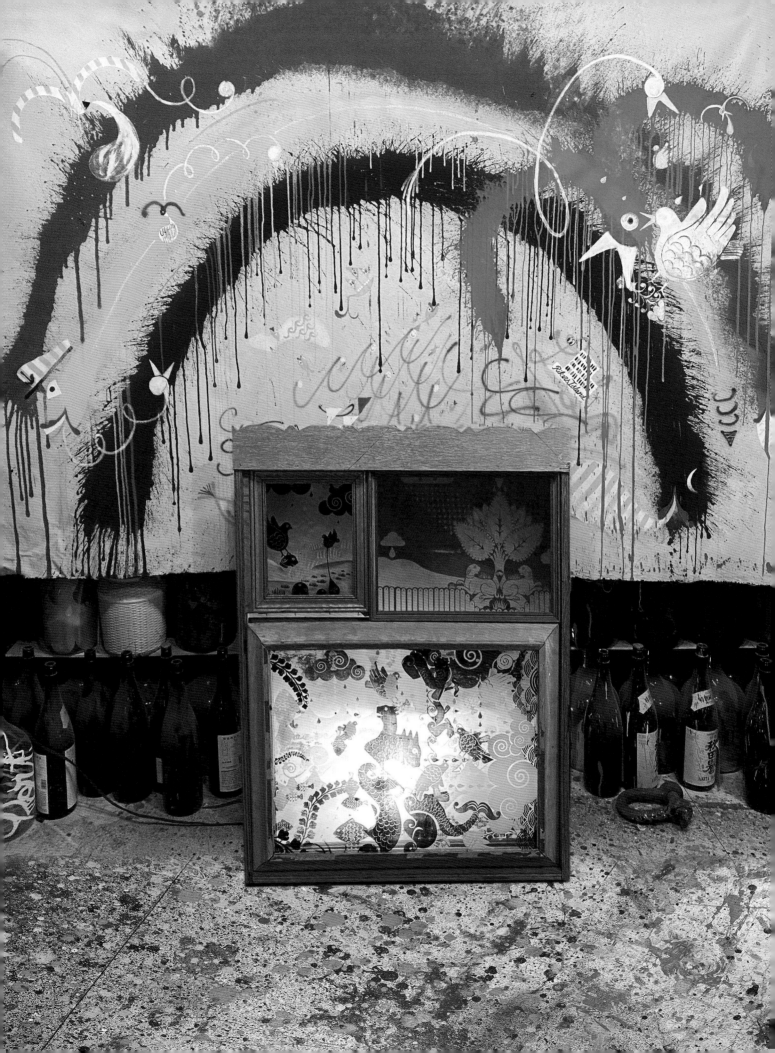

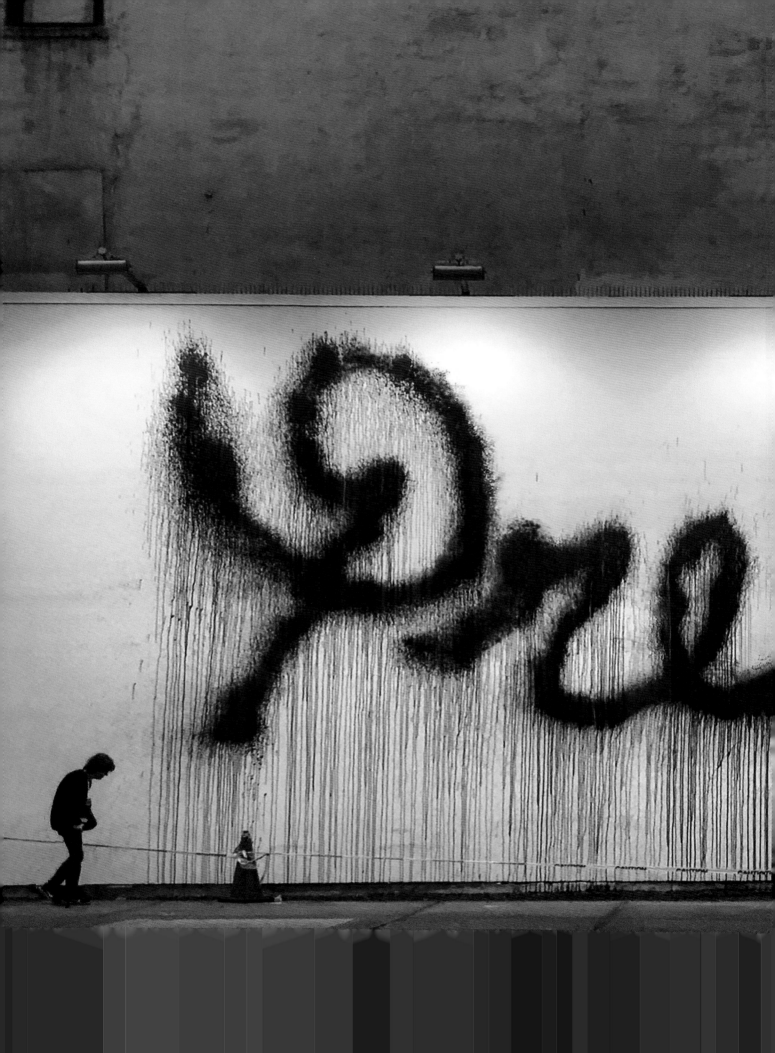

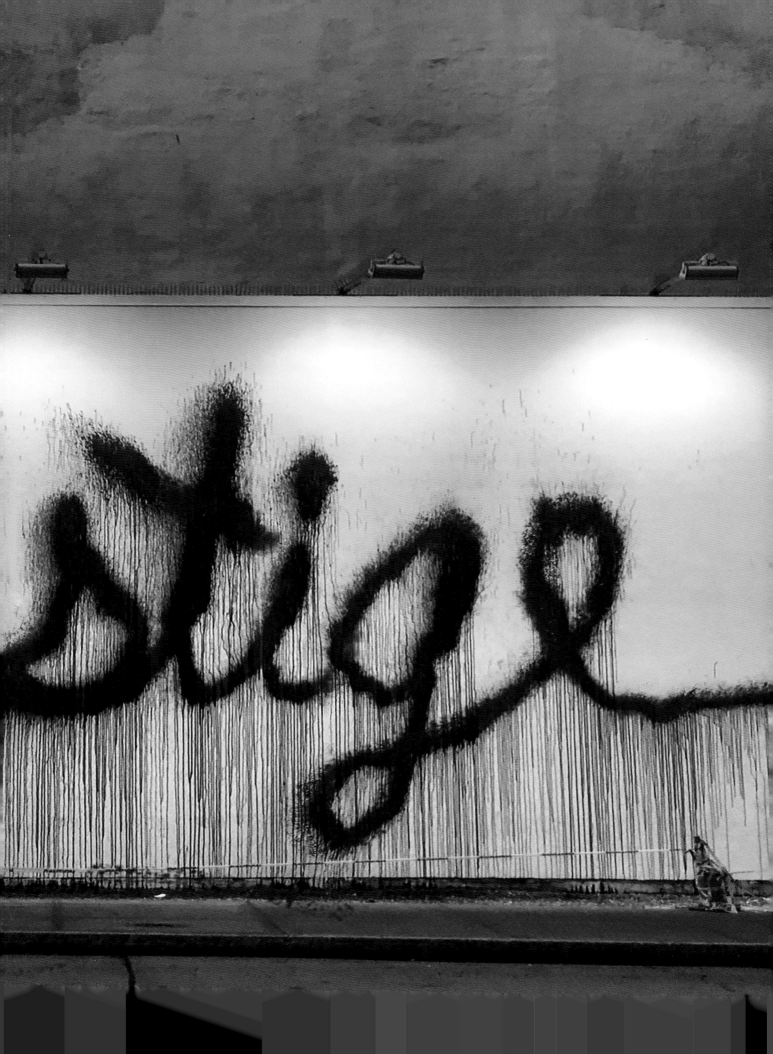

INDEX

PHOTO CREDITS

FRESH PAINT NYC
LUNA PARK
NATASHA RIVERA
DENNIS KANE
KIRAN CHITANVIS
ANASTASIOS PONEROS

FIRST EDITION 2022
PUBLISHED BY @BLURRINGBOOKSNYC

@PORKNEWYORK